630.74 Mil
Fair culture : images from
Indiana fairs
Miller, Harold Lee.

FAIR CULTURE

FAIR CULTURE
IMAGES FROM INDIANA FAIRS

HAROLD LEE MILLER

Indiana Historical Society Press | Indianapolis 2011

WABASH CARNEGIE PUBLIC LIBRARY

©2011 Indiana Historical Society Press

Printed in China

This book is a publication of the
Indiana Historical Society Press
Eugene and Marilyn Glick Indiana History Center
450 West Ohio Street
Indianapolis, Indiana 46202-3269 USA
www.indianahistory.org
Telephone orders 1-800-447-1830
Fax orders 1-317-234-0562
Online orders @ http://www.shop.indianahistory.org

The paper in this publication meets the minimum requirements
of American National Standard for Information Sciences—Permanence of Paper for Printed Library Materials,
ANSI Z39. 48–1984

Library of Congress Cataloging-in-Publication Data

Miller, Harold Lee.
Fair culture: images from Indiana fairs / photographs
by Harold Lee Miller; essay by Gerald Waite.
 p. cm.
ISBN 978-0-87195-278-3 (alk. paper)
1. Agricultural exhibitions—Indiana—Pictorial works.
2. Fairs—Indiana—Pictorial works. 3. Indiana—Social life and
customs—Pictorial works. 4. Community life—Indiana—Pictorial works.
I. Waite, Gerald. II. Title.
S555.I6M55 2009
630.74'772—dc22
 2009011487

No part of this publication may be reproduced, stored in or introduced into a retrieval system, or transmitted,
in any form or by any means (electronic, photocopying, recording, or otherwise) without the prior written
permission of the copyright owner.

CONTENTS

PREFACE vii
HAROLD LEE MILLER

FOREWARD ix
PHILIP GULLEY

A FAIR PROFILE 1
HOOSIER COUNTY FAIRS
GERALD WAITE

PHOTOGRAPHS 15
HAROLD LEE MILLER

PREFACE

HAROLD LEE MILLER

This has been a labor of love for me, photographing people at fairs from 2005 to 2008.

When I first had the idea for this project, I thought I was going to be documenting a passing American cultural tradition. What I knew of fairs was the midway and people displaying animals. While midways are not in any danger of becoming extinct, I assumed the practice of people raising animals and then showing them at the county fair certainly was.

I greatly exaggerated reports of the fair's demise.

It's not that I'm unfamiliar with agriculture. My family comes from rural American farms, and I spent many days working on my Uncle Mickey and Aunt Vivian Pope's farm in southwest Arkansas during breaks from college. What I'm unfamiliar with is the subtle culture of small communities that still depend on agriculture, and the families who are still connected to farming, even if their living is in an office, a school, or a factory.

And I did not appreciate the many facets of county fairs that are not related to agriculture—the cooking, the sewing, the beauty queens, the strongman competitions, the food, and the demolition derbies. So when I started going to fairs and making these images, the more I saw the more I realized there was still plenty of life in this bit of Americana and that it was still very important to far more people than I thought.

Because I was raised in a military family I lived much of my life before I was twenty-one outside of the United States. When I did live in the United States it was usually on a military base. This gave me an outsider's perspective on much of America. I romanticized small-town life and longed for what my father, Harold Sr., had when he grew up—a place he could call home, a town where most everyone knew who he was and who his family was. Much of my photography projects that longing onto my subjects. It does not take a therapist to look at my work and see that I'm documenting subjects that I perceive as disappearing, and that there is a nostalgia and melancholy in the images.

What I hope is that in making the images I've made—those in this book and all the ones that came before—I have avoided making caricatures of the subjects, and that while the photographs contain some of the nostalgia I feel for a life I never knew, the result is not nostalgic, but documentational. I have no interest in presenting a romanticized view of people or places, because people and places are more complex than that. I show the viewer what interests me, and I work to deliver the truth as I see it.

The people in these images are special, in the way that all people are special. When I ask someone if I can take their photograph, often the reaction I get is puzzlement. The average person does not consider himself or herself worthy of being singled out and presented to the public, but they are worthy of it. Part of what I'm trying to accomplish is to show just how interesting and uncommon each of these individuals really is, whether they know it or not. Each and every human photographed in this book is now part of our recorded American history, and in a hundred years that generation will see our unique presence in a way that we cannot see it now—marvel at our clothes, our faces, and our humanity, and thank us for letting ourselves be living artifacts of our time.

My thanks to my wife, Ellen, for her steadfast support over the years; Heather Rodocker, for her help in making many of these images; my daughter, Grace, for her kind assistance with this project; and the many people who bravely agreed to be the subjects of these photographs.

FOREWORD

PHILIP GULLEY

Several years ago, the county in which I was raised and still live bulldozed the 4-H Fairgrounds next to the old folks' home and dropped $20 million on a new 4-H Fairgrounds and Conference Complex. The attendance tripled, the county began charging for parking, and every square inch of the place was paved, ridding the fairgrounds of its ambiance—mud puddles and clumps of cow flop—and thus the ability to discern the farm boy from the town boy. Farm boys plow straight through the mud and manure, town boys step exaggeratedly around them.

I miss the old fairgrounds and the low white barns whose boards were rubbed smooth by the livestock lounging against them each July. The wood captured the farm smell then doled it out through the year, so that no matter when you were there, it always smelled like fair time. But there is no place in the new for odor to catch and stay. A day after the fair is over, after the animals have returned to their farms and the cotton candy and Polish sausage booths trailered away, the scent is gone with them. Nothing is left in their wake, nothing lingers to trigger the senses and memories of those July moments when Sam Barker hauled his half-dozen Angus in and looped them around the sale barn, or when Dara Smith brought her perfectly baked snickerdoodle cookies on a china plate and won grand champion and went to state.

This is the fair culture I remember, the one I miss, which Harold Miller has captured so perfectly in this gem of a book, *Fair Culture: Images from Indiana Fairs*. The antique tractors, the boy and his chicken, and the teenage beauty scooping manure one minute, donning her queen sash the next minute to present a ribbon to the lady who grew the best tomatoes.

See for yourself, open the cover, turn the page, see if does not all come back, peeling away the years. You are fourteen again. Your mother has dropped you off early in the morning with five dollars in your pocket for lunch and supper, and a word of caution to avoid the carnival games that can leave you stranded and penniless in the wink of an eye and the whisk of a hand.

What I would not give to return to those days, to roll back the decades, to smell the smells, to see once again the girl from Hazelwood, whose name I never learned, but who sat beautifully perched on a smooth rail, each dusky evening of my 4-H adolescence, keeping watch over her flocks by night.

AT THIS YEAR'S
COUNTY FAIR
ALL OUR FRIENDS
WILL BE THERE
GATHER KIN
AND COUSINS NEAR
AND EVERYTHING
WE LOVE IS HERE

— CARRIE NEWCOMER

A FAIR PROFILE
HOOSIER COUNTY FAIRS

GERALD WAITE

Mom's apple pie can still be found in the county fair that judged it the best of the best. The values we embrace in a romanticized America are found in the floral, sewing, and 4-H barns of hundreds of county fairs throughout the Midwest. School art projects, photography, pies, cakes, and flower arranging compete with the sights and sounds of carnivals, horse racing, farm implement displays, home improvement schemes, and great food at the local church booths. The very young ride the ponies and the kiddies' rides, while teenagers scream on the Tilt-a-Whirl and the Rocket. High school boys pitch to win the biggest doll for their best girl of the summer season, and others toss hoops for a duck or rabbit. Prettiest baby, fair queen, and senior queen contests link generations of Indiana families all who grew up longing for school to be out and the fair to come to town. County fairs still mark a special spot in the annual calendar for many Hoosiers.

Fairs, agricultural exhibitions, and annual community festivals have been a part of the human experience since the Middle Ages. The word "fair" itself has a variety of meanings that are associated with commerce, religion, trade, agriculture, and industry to name a few. From the religious zeal of the medieval English fairs, to the gaudy expositions of the late nineteenth and twentieth century, and the county fairs of rural America, fairs have created portraits of the present, and the idealized future, rooted in the past. They also embody opposing representations of life through competitions of the best of the best, and the carnival image of seamier sides of life.

There is no concise definition of a fair in Indiana. Even though there are a variety of assumptions about what the word "fair" means and most of those are related to a county fair, there are still many other meanings, almost as many as there are towns in Indiana. A street carnival, a 4-H fair, a county fair, a town festival, an art fair, all of these can and are listed as fairs. Examples in Indiana include the 500 Festival, Broad Ripple Art Fair, Covered Bridge Festival, Firefly Festival, Indy Jazz Fest, Jasper Strassenfest, Mansfield Village Mushroom Festival, and others too numerous to name. The list can be infinite, with the possibility of any sort of event being listed as a fair or festival of some sort.

County fairs, in their Indiana version, tend to be small town and agricultural in nature, although fairs can be found in any size community. Elkhart County boasts one of the nation's largest fairs, second only to Orange County, California. Most fairs are similar in overall structure, with agriculture, entertainment, and commerce, but they are also unique institutions that take on character from the local area. From the ethnic festivals of the East to the rodeo extravaganzas of the West, the aesthetics of the fair reflect the value system of the communities they represent.

Early American fairs had their roots in agricultural societies of the eighteenth century. They were designed to improve the scope and practice of agriculture by educating the masses through sharing the agri-science of the time and, in many instances, they were promoted by well-to-do community members who had livestock or farm products to

sell. In some instances they were even advertised as meeting places between buyers and sellers. Early New England events were places where farmers of all classes could interact, compare goods, and deal in livestock. Home production of foodstuffs and textiles were judged and knowledge shared as a means of upgrading the community.

Entertainment said to be frivolous, seedy, vulgar, or sometimes characterized as "downright immoral" has been a part of the fair scene since at least the middle of the nineteenth century. Often seen as a necessity by promoters of the fairs, but never fully reconciled by the aristocratic fathers of agricultural enlightenment and betterment, entertainment and carnival was sometimes mediated by host communities so as not to replace the original intent of education. Even the word "concessions" was said to have originated as a concession to the lower classes.

The midwestern version of the fair, "The County Fair," geographically located between western New York State and Iowa, is considered by many as the epitome of the community agricultural exposition. At one time every county seat boasted the "best fair for miles" and made promises such as "more imported horses and cattle exhibited at this fair than were ever on the grounds at any previous fair." Indiana counties were among the first of the organized agricultural societies of the mid-nineteenth century that promulgated the rise of the early agricultural fairs. The Indiana legislature authorized "An Act for the Encouragement of Agriculture" in 1852, which stated that it should be the "duty of such societies to provide premiums for the improvement of soils, tillage, crops, manures, improvements, stock, articles of domestic industry, and such other articles, productions and improvements as they shall deem proper." This act allowed the development of the Indiana State Fair and the county fair system as a tool for the development of America's most important industry of the time—agriculture.

County fairs have since become institutionalized annual rituals of evaluation within our Hoosier communities. Everything imaginable that the community can produce, both agrarian and urban, can be categorized and judged. Prizes called "premiums" are awarded for every category; they may be monetary or just ribbons, but some degree of public recognition is always included, even if it is just bragging rights. Almost every aspect of a community can be created as a contest category for judging, with beauty contests, cute baby contests, twin contests, and other people-oriented classes as popular perennial fair favorites. Traditional agricultural categories such as cattle, swine, sheep, and horse events may be found in most locations but, updates such as car shows, tractor pulls, and automobile or motorcycle racing are numerous also. In many locations throughout Indiana, the most popular nights are those of the demolition derby and high school band contests. Control of the fair is always at a local level so the aesthetics of the gathering represent the taste of each individual community. All communities work to maintain what they define as tradition, but when participation and attendance decline, organizers react with changes and efforts to modernize. Changes in the fair may reflect the direction of culture change within the community or the larger society, or they may themselves facilitate and direct change.

Indiana's earliest fair was also one of the nation's first organized agricultural fairs. Erwin D. Scott writes about the first Knox County Fair in 1809 in his *History of Indiana's Oldest County Fair*. John D. Hay and Symmes Harrison were the principals in this effort, offering a premium list of four hundred dollars to encourage "domestic products." The largest premium paid was for the best brood mare showing a foal. The Knox County Fair was reorganized at least three more times before the state push for agricultural societies in the 1850s and its fifth fair was held at the courthouse in 1855. Officers were listed and memberships sold for one dollar. The 1850s version of the fair included agricultural, mechanical, and domestic manufacture departments. Premiums of five dollars were also paid for essays on stock raising and agriculture.

The Delaware County Fair or Muncie Fair as it was known, like most in the state, was organized in 1852 with the specific intent of the reformation of old customs and habits and "giving a place to

EVERYTHING IMAGINABLE THAT THE COMMUNITY CAN PRODUCE, BOTH AGRARIAN AND URBAN, CAN BE CATEGORIZED AND JUDGED. PRIZES CALLED "PREMIUMS" ARE AWARDED FOR EVERY CATEGORY; THEY MAY BE MONETARY OR JUST RIBBONS, BUT SOME DEGREE OF PUBLIC RECOGNITION IS ALWAYS INCLUDED, EVEN IF IT IS JUST BRAGGING RIGHTS.

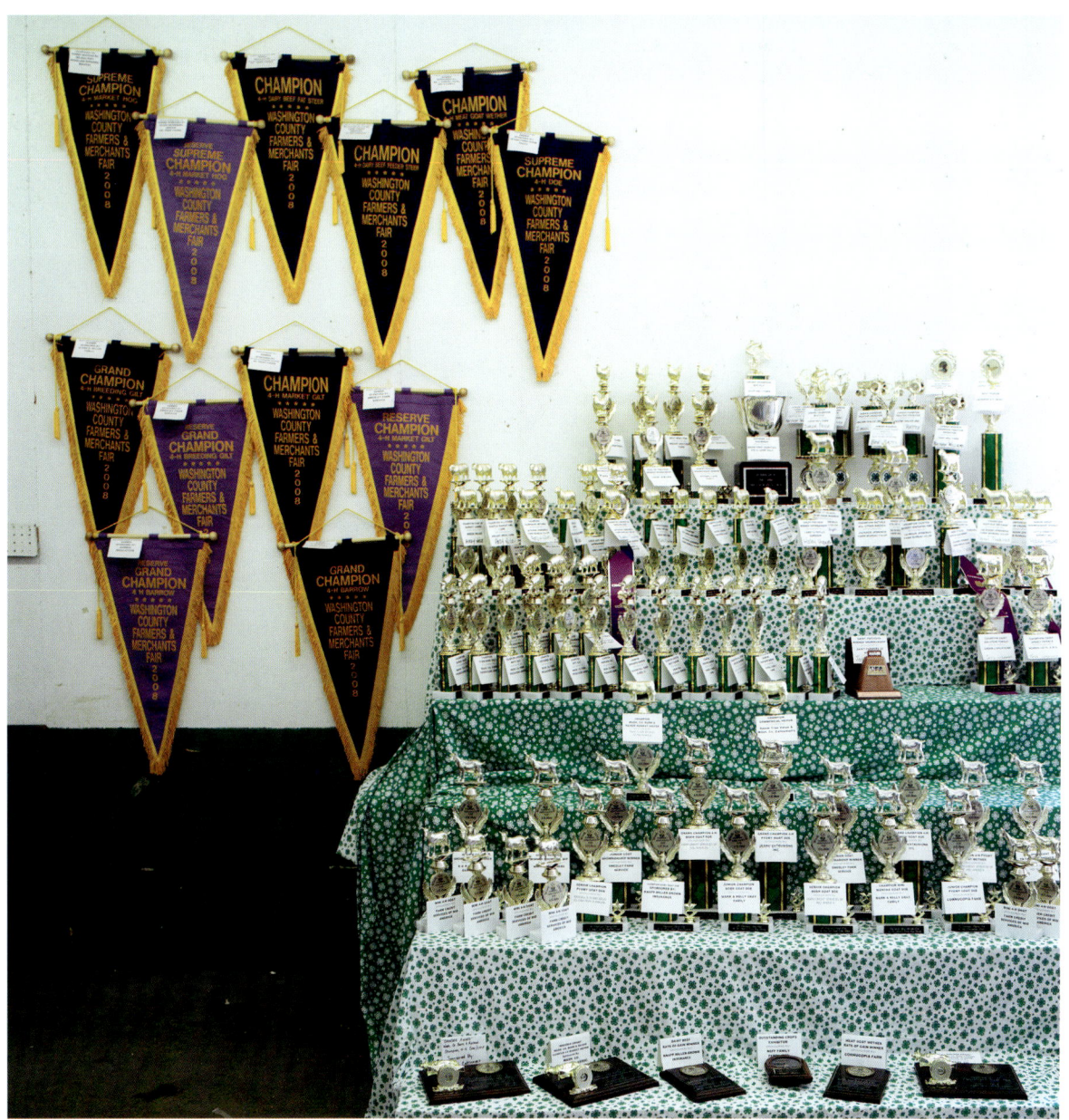

Washington County Fair

"A GOOD COUNTY FAIR, AMONG ALL ITS OTHER MERITS IS AN **EVIDENCE OF THRIFT ON THE PART OF THE FARMERS** OF THE COUNTY. A POOR FARMER **CARES NOTHING ABOUT THE FAIR,** HE HAS NOTHING TO EXHIBIT AND HE DISLIKES TO ATTEND FOR HE IS REMINDED BY THE ELEGANT PRODUCTS WHICH HIS NEIGHBORS DISPLAY **WHAT FAILURES HE AND HIS FARM ARE.**"

— MUNCIE DAILY NEWS, JULY 28, 1879

systemic and scientific farming." The first organization to sponsor the fair was an agricultural society formed on March 4, 1852. Little is known of these early years of the fair since either no records were written or have since been lost. T. B. Helms's 1881 account indicated that the first fair was held on July 4, 1852, and although Governor Joseph A. Wright was invited to speak, addresses for the occasion were delivered instead by prominent Muncie citizens "of a nature satisfactory to all." The first two fairs were perhaps held on the courthouse square but the exact location is no longer known. According to Helms, "Premiums were offered on horses, cattle, sheep, swine, wheat, corn, potatoes, grass seed, butter, cheese, domestic manufactures, farm implements, and various articles displaying mechanical skill, poultry, fruit and flowers."

Richmond's first fair organized in the 1850s also promised the "best fair in the State, or the West." News accounts for this fair went on with invitations for "agricultural friends and mechanics to be on hand with specimens of the products of the farm and the shop." And finally this fair board authorized all unmarried ladies to be exhibitors free of charge.

Many of the early fairs only met every few years depending mostly on the solvency of the parent organization and the possible meeting places. Franklin County's fairs moved between Brookville and Metamora in alternating years. County commissioners of some locations funded fairs with premium money, others created agricultural associations that sold stock subscriptions or charged admission. Often fairs took a backseat to wars and other forms of unrest. Vanderburgh County's fair went on unpaid leave when the U.S. War Department took over its grounds as a marshaling yard for horses during the Civil War. This same fair was described as a "farce after the war and lost public support." It was reorganized in 1873 and the following year the fair was a success when forty thousand people attended. It was described as "devoted more to urban life, manufactured goods and delights of the turf." It declined again after 1873. Even when fairs managed to survive wars they went from front page to classified status in the local news media. Although many fairs managed to weather the war years of the 1860s, they did not gain prominence in local affairs again until the 1870s.

The reincarnation of the fair in the 1870s included a broader scope of mechanical and manufacturing concerns that reflected the beginnings of the industrial age in Middle America. Indiana had 161,289 farms in 1870, ranging in size from one acre to more than a thousand acres, but already there were concerns about the rapid development of the country and the increasing urbanization of the state. The Jackson County Fair in Brownstown got its start in the 1850s when the county commissioners leased a portion of the County Poor Farm to the Agricultural Society, said real estate to become the property of the Society at the end of the lease. The fair was billed as the "best in the nation." An account for the 1871 fair said that "Mrs. Peter Platter had 40 varieties of canned fruit, 30 varieties of jellies, 38 varieties of preserves, 17 varieties of fruit butters, 29 varieties of pickles. Never before had this large an assortment been seen at any fair, state or county." By 1888 the fair included "carpenter and cabinet work, manufactured leather, millinery, and crochet work." This fair and others in the state included steam-driven implements, free return train fares for stock entries, and displays of wagons, buggies, and carriages. Admission was twenty-five cents for an individual, two dollars for a family and buggy up to six, and two dollars and fifty cents for more than six. Also, most fairs cautioned that hired hands were not to be counted as family. America was moving from a culture of rural production to one of industrialization and consumption, and the rituals of modernization were held annually at the county fairgrounds.

An article on the front page of the *Muncie Daily News* July 28, 1879, stated: "A good county fair, among all its other merits is an evidence of thrift on the part of the farmers of the county. A poor farmer cares nothing about the fair, he has nothing to exhibit and he dislikes to attend for he is reminded by the elegant products which his neighbors display what failures he and his farm are."

This piece was not associated with the fair's occurrence, but appeared two months in advance of the fair that year, perhaps as inducement to participation. It also points to an attitude on the part of many that saw fairs as specifically educational. Racetracks and fairgrounds were maintained as separate entities in many counties until the 1870s. Tracks were a source of social struggle among early agricultural societies. Horse racing was seen as lower-class entertainment of a doubtful nature, and its place within the agricultural fair was not secured until the 1870s and then only through the argument that it was specifically agricultural in nature. Also, many fairs that had struggled financially in earlier years used racing as source of income through gate and grandstand receipts. Often when community agricultural organizations created a fair specifically without racing, gambling, or carnivals, the fair lasted only a few years before it would either reincorporate its earlier culls or disappear entirely. It is worth noting that circus visits seemed to be timed for the middle of summer, and even though at least in some towns they used the fairgrounds, they were

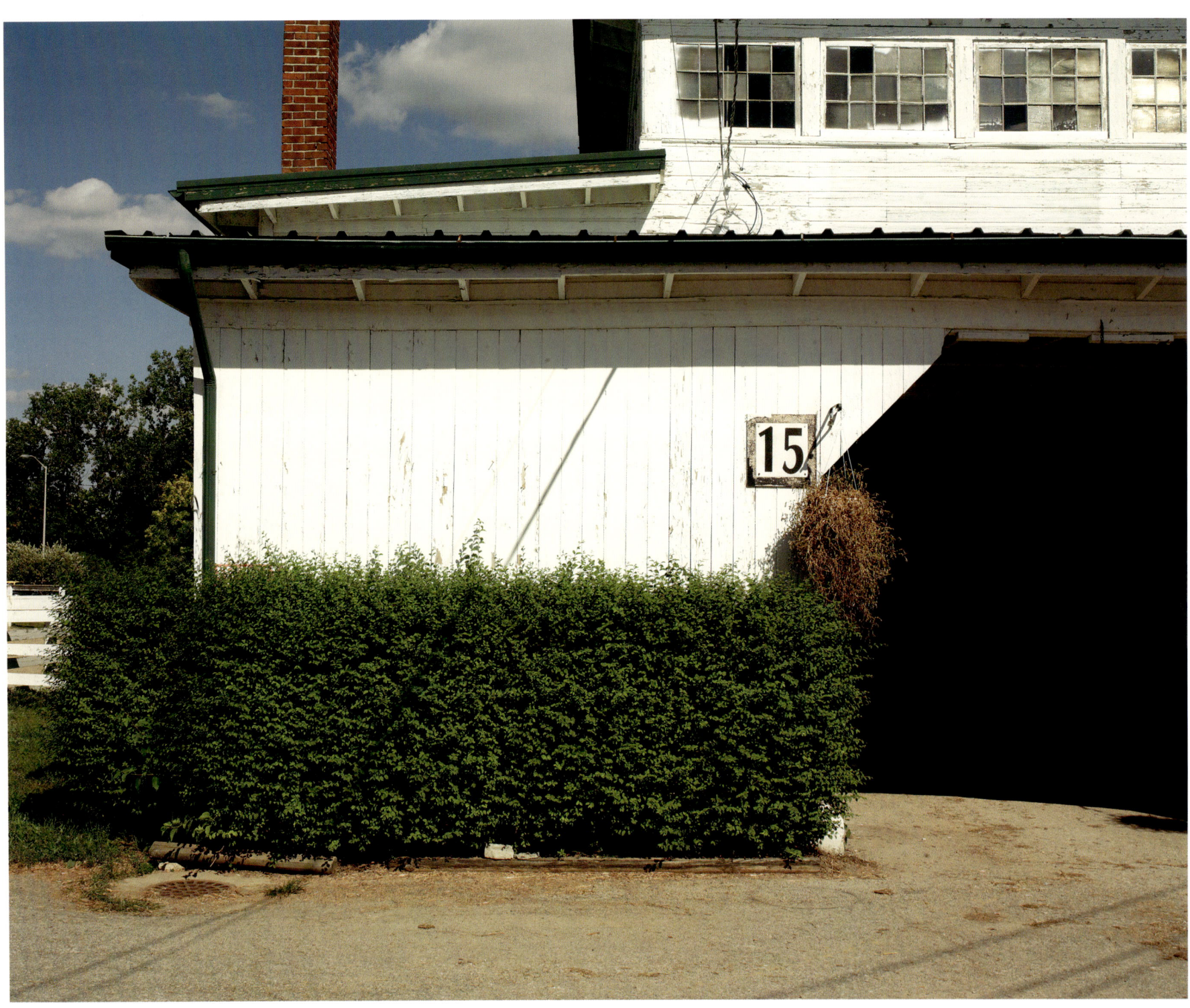

Indiana State Fair

not associated with the fairs until closer to the beginning of the twentieth century.

An advertisement for the thirty-first annual fair in the *Muncie Daily News* in 1883 touted the following: "New Features . . . Trotting Races, Pacing Races, Running Races, Mule Races, Bicycle Races, Foot Races Etc." and also advertised the new electric street rail. For its fourth annual fair in 1880, Fayette County offered three thousand dollars in premiums and billed itself as the Eastern Indiana Agricultural, Mechanical, and Trotting Park Association. Other types of entertainment—those termed "light concessions"—had no part in some county fairs until as late as the 1920s. The boundaries between education and entertainment and their place in the fair were the source of much discussion throughout the late nineteenth and the early twentieth century.

The last quarter of the nineteenth century is seen by many as the high point of the essential agricultural fair. Speed Rings (horse racing) and the Ladies Building, just to name a few, found their way into the main offerings of every fair and enlarged the scope to social events of a regional scope, even while diminishing the agri-educational import of the founding fathers. Permanent grounds were purchased by local fair boards and by 1890 every county in Indiana had a fair or was associated with another county in a fair. Fairs added expanded premium lists to include fine arts, horticultural items, and an educational department for "contributions from the schools of cities." This last, with its clearly stated "cities," represents an increased urban growth and an attempt to capture the broader interest of a changing population. In 1880 about 125 million people attended fairs in America for education, entertainment, socializing, or diversion from an otherwise hard-working life.

Fairs of the 1890s emphasized future abundance and the "world of tomorrow" as themes for a growing nation entering a new millennium. Premium lists from the early fairs, as well as news coverage, show the fairs to be advertised as regional events and yet to address agendas that were specifically local. Early fairs in Vincennes, Indiana, were said to have exhibitors from Illinois and Kentucky. Almost all fairs of the time were billed as "Open to the World." Even though many have existed through at least five wars, a major depression, and several minor recessions, these fairs, at least in outward appearance, seem a mainstay of local values, with premium lists changing little since their inception. If one were to leave out the categories of "jacks, jennies and mules," "light draft horses," and "horses of a general purpose," the agricultural premium lists of 1880 and 1952 would be amazingly similar. The educational department was dropped from the list as an area for public critique in some places, but that again is a local phenomena, since those categories are maintained at other nearby fairs. We can look at the premium list as the stable center around which the annual extravaganza known as the fair creates or reflects cultural change.

If the last of the nineteenth century is seen as a high point of the agricultural fair, then the first half of the twentieth century would be the florescence of the modern fair. The early twentieth century fair encapsulates the boundary between America as a rural nation and the creation of an industrial giant. Improvements such as electrification of the grounds, refrigeration, and bank sponsorships of pig and calf clubs brought change, especially commercial, at an increasing rate. Horse, car, and motorcycle racing competed for attendance with circuses, carnivals, and local band nights. Such unusual events as elephant shows, performing midgets, the "Kerns family the world's fattest family group," the bucking ford, and the bucking buffalo promised entertainment for the masses far beyond anything the 1852 agriculture societies ever envisioned. Everything that could be judged was judged, from mom's apple pie to the general health of children in a family. Premium entries included "Lot 56–best baby boy over one year and not exceeding one year and six months-shown by mother, Prize $2." The first car shows as a means of promoting and merchandising the new automobile appeared in 1916 newspaper advertisements for the fairs. The advertisement offered a new Overland Utility Pleasure Roadster for $735. The 1920s brought the American eugenics movement and programs such as "Fitter Families for Future Firesides" and "Race Betterment Week" at the fair. People were encouraged to have their families evaluated for the dubious "Blue Ribbon Family Award."

County fairs in the twentieth century were still regarded as agricultural events, despite the intrusion of commerce. Most fairs were scheduled in August and September because of the availability of garden produce for horticultural competitions, but also because it was considered a "slack time" in farming—after cultivation and before harvest. The Farmer's Institute, organized at Purdue University as a cooperative effort between the university and the State

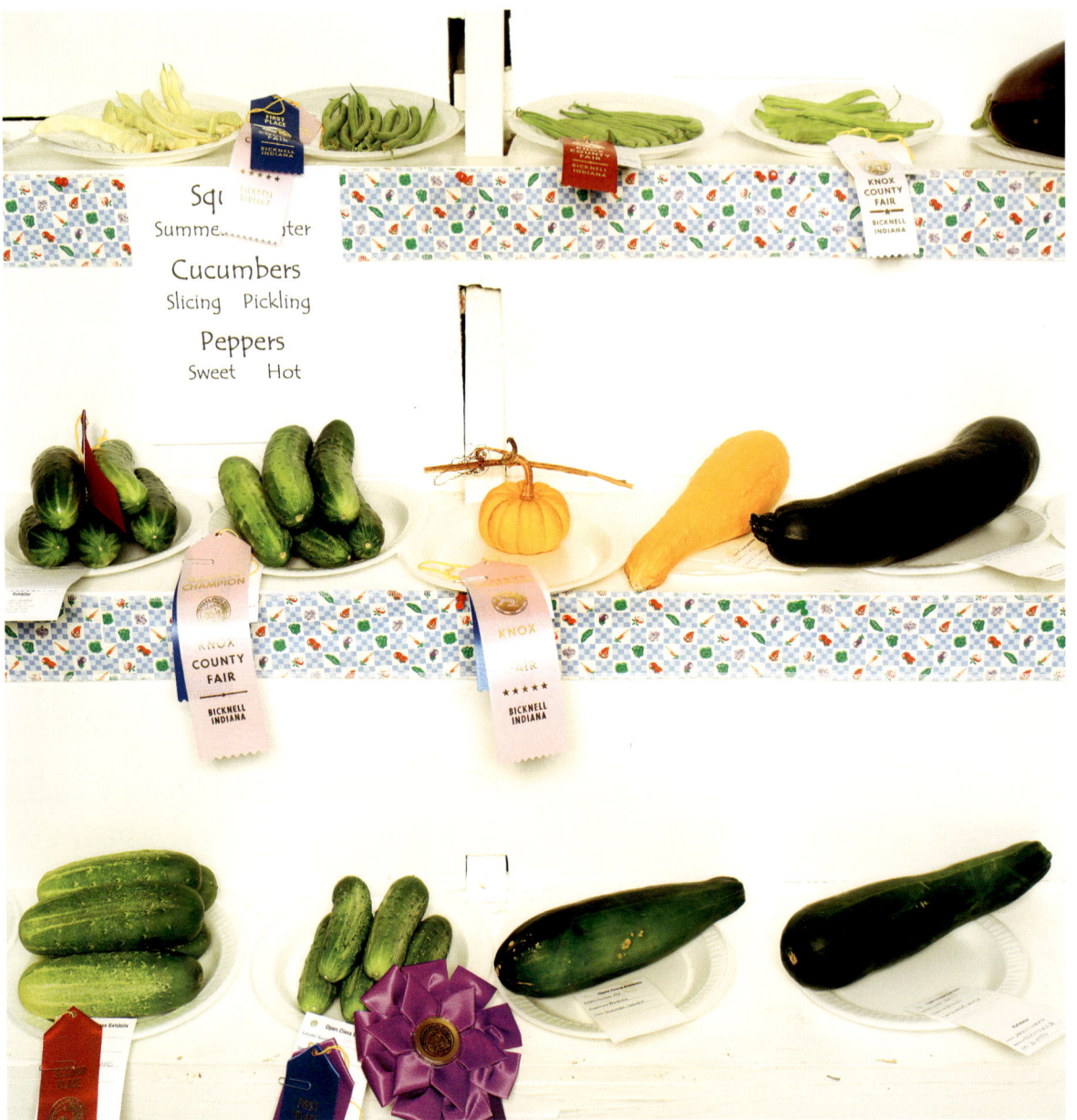

Knox County Fair

Board of Agriculture during the 1880s, was means of adult education and community development that encouraged an agricultural emphasis. In 1915 there was a Farmer's Institute Fair listed in Jackson County, although not a county fair, in Seymour. It was held in the upstairs of the Majestic Theater and had displays of farm produce, canned products, and fancy work in the women's department.

The Grange, the nation's oldest agricultural organization, also had a hand in the maintenance and occasional renovation of some Indiana fairs. One Grange fair in Indiana is said to have bragged that it was "neither a horse race nor gambling resort, but a truly agricultural fair." The Indiana Farm Bureau also promoted agriculture and worked to maintain the fairs as agricultural events.

Several developments in the early twentieth century helped keep the agricultural focus on fairs. The Smith-Lever Act of 1914 created the Agriculture Extension Service, whose purpose was to provide federal aid for community education in agriculture as a partnership with land-grant universities. This allowed the hiring of county extension agents who utilized the county fair as the medium for providing agricultural education. In several instances, these offices were responsible for the creation (or re-creation) of fairs. The Smith-Hughes Act of 1917 encouraged the junior division of the extension service, or what is known today as 4-H. Initially called "farm clubs"—with local sponsorships by banks and other such institutions the boys' and girls' calf clubs, boys pig clubs, or similar clubs in many communities—these early organizations promoted progressive farm values and paved the way for the later 4-H clubs. One local public-service announcement in the Muncie paper said that students would be excused from school for fair attendance and that they only had to bring their ticket stub to school to be counted present for the day.

The 1930s fairs became even more important as forms of inexpensive entertainment and situations for social networking in the Great Depression economy of the Midwest. A return to the farm movement spurred the agricultural education functions of the fairs as people looked to refresh the knowledge they had lost after a generation or more in town. By this time fairs were seen as permanent institutions offering entertainment and education in agronomy, manufacturing, and merchandising. Several fairs also included local Girl Scout Troops in the activities for the first time.

World War I and World War II both drew extensively from farm labor pools for soldiers. During the 1920s and 1930s, most Indiana fairs started having veterans' days as one of its special features. Patriotism also became a standard product of the fairs, especially during the war years. War bonds were sold, politicians were featured as prominent speakers, and military drill teams and bands became popular featured events. The fairs themselves, however, were pushed off the front pages of the papers and took up residence in the sports pages or classified advertisements during the war years.

The extravaganzas of the mid-century fairs included such events as a wagon-train caravan from the first Indiana state capitol at Corydon to Indianapolis, presidential candidates such as Adlai Stevenson speaking at the larger fairs, horse shows as well as the usual racing events, and an expanded premium list that included dog and pony shows. Attendance was down at some fairs during the early 1950s because of the polio epidemic, but most seemed to prosper.

Youth aspects of fairs as expressed through organizations such as 4-H, the Future Farmers of America, and Future Homemakers of America are some of the driving forces in the maintenance of fairs as an annual ritual. Four-H created funding and credibility for other areas of the fair. Some fairs do not have major entertainment or carnivals, but feature local food stands, dance nights, talent shows,

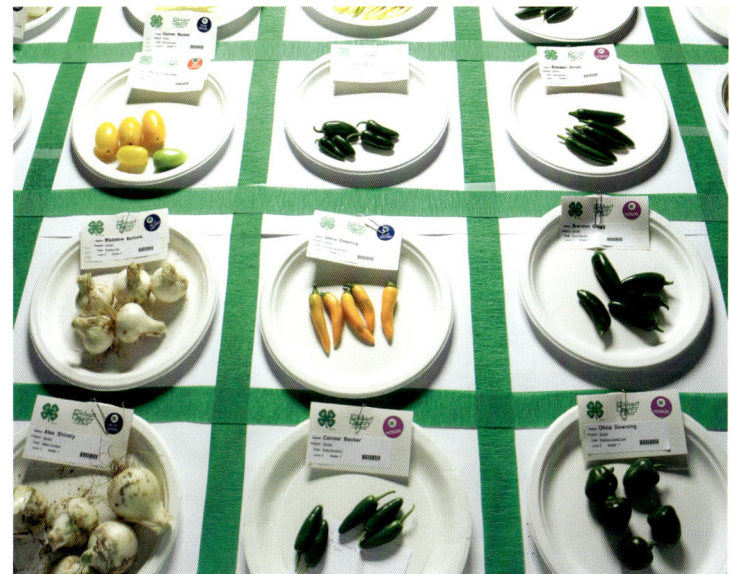

Elkhart County Fair

and tractor pulls. Most of these fairs are still known as 4-H fairs, where the community's youth can bring yearlong projects for evaluation. Many of the 4-H fairs offer competitions for the whole community, with restricted areas for club members and open-to-the-world categories for all others. The Johnson County Fair in Franklin offered this advertisement on its Web site for the 2006 fair: "The Johnson County Indiana 4-H & Agricultural Fair is located in Franklin, Indiana and is held each year in the month of July. In addition to all the 4-H contests of every type craft, animal, bird, and aquatics we have a full midway and concessions, demolition derby, competition tractor pulls, antique tractor pulls, even pedal tractor pulls, as well as hundreds of commercial exhibits and many events." The Web site also noted the days, hours, minutes, and seconds until the opening of the fair.

John Hains, superintendant of Hamilton County schools in 1904, is credited by some with founding 4-H in Indiana. The foundation for this unique program, however, really began in July 1862 when President Abraham Lincoln signed the Morrill Act into law. This legislation encouraged the teaching of agriculture and mechanical arts in every state and granted certain public lands to any state that would use the proceeds from these sales to establish a college. These colleges were often referred to as "land grant" colleges. John Purdue, a Lafayette businessman and civic leader, offered $150,000 and a hundred acres of land to establish a college. Today, Purdue University in West Lafayette is known for engineering and advanced agricultural studies. Four-H

programs in Indiana were initiated and encouraged by Purdue University and, of course, with help from the 4-H Foundation of Indiana, civic leaders, the State of Indiana, and institutions of different counties in Indiana.

Four-H has grown into an educational program designed to meet the needs of the country by developing citizenship, leadership skills, and self-reliance in future generations of citizens. Hoosier children learn scientific methodology in understanding and solving problems and exploring future careers. Various projects such as gardening, agriculture, animal husbandry, canning of fruits and vegetables, bread making, baking, and sewing are among the domestic and agricultural skills taught in 4-H. The modern version of 4-H, however, has adjusted to a rapidly growing urban population in Indiana and although there is still a rural emphasis in many areas, clubs such as aerospace, computers, entomology, genealogy, photography, and rockets are representative of the changing demographics of Indiana. At the Elkhart County Fair in 2008 there were more than "1,000 non-breathing" entries submitted for judging, many of them photography and art-related projects.

The emblem of 4-H is a four-leaf clover with an H in each leaf. The site of this logo is familiar to almost every person in the state but many have lost or never known the associated meanings. The emblem stands for Head, Heart, Hands, and Health:
- Head—learning to think, making decisions, and gaining valuable knowledge.
- Heart—being concerned with welfare of others, accepting the responsibilities of citizenship, gaining attitudes to live, and learning how to work with others.
- Hands—learning new skills, perfecting skills, and developing pride in work.
- Health—practicing healthful living, protecting the well-being of self and others, and making constructive use of leisure time.

Membership is open to boys and girls from grades three through twelve. The program has become the largest youth development organization in Indiana, with more than three hundred thousand members, twenty thousand adult volunteers, and three thousand clubs, according to the 4-H Foundation's Web site.

One of the most important functions of 4-H and the fairs is the maintenance of community values. If our lifestyle is seen as fractured and individualistic by some, 4-H and the fairs become some of the most important nonreligious mechanisms to repair that damage. Everyone interviewed for this project said that the fair was about family, friends, and multigenerational involvement. Children worked with grandparents to do projects for their clubs and get them to the fair for judging. Community members give unselfishly of time and resources to foster projects with youths whose families might not have the resources to otherwise participate. Fairs become a means of community connections and giving. At Elkhart County, the authors were told that the fair depended on more than 1,500 volunteers and a fair board of 125 people. At this same fair we interviewed Mikayla Diehl, fair queen, and her grandmother, Katie Sautter, the senior fair queen—truly the epitome of generational involvement.

Fairs also provide the opportunity for local civic organizations to raise money for charitable causes within the community. Groups such as the Optimists, the Kiwanis, Lions Clubs, and others raise money for local projects, community-sponsored scholarships, and local schools. Church groups sponsor food stands and events that raise money for their particular needs, and other organizations such as the Red Cross, local hospitals, county sheriffs, and political organizations set up stands for community organizing and information distribution.

Opposite: Indiana State Fair

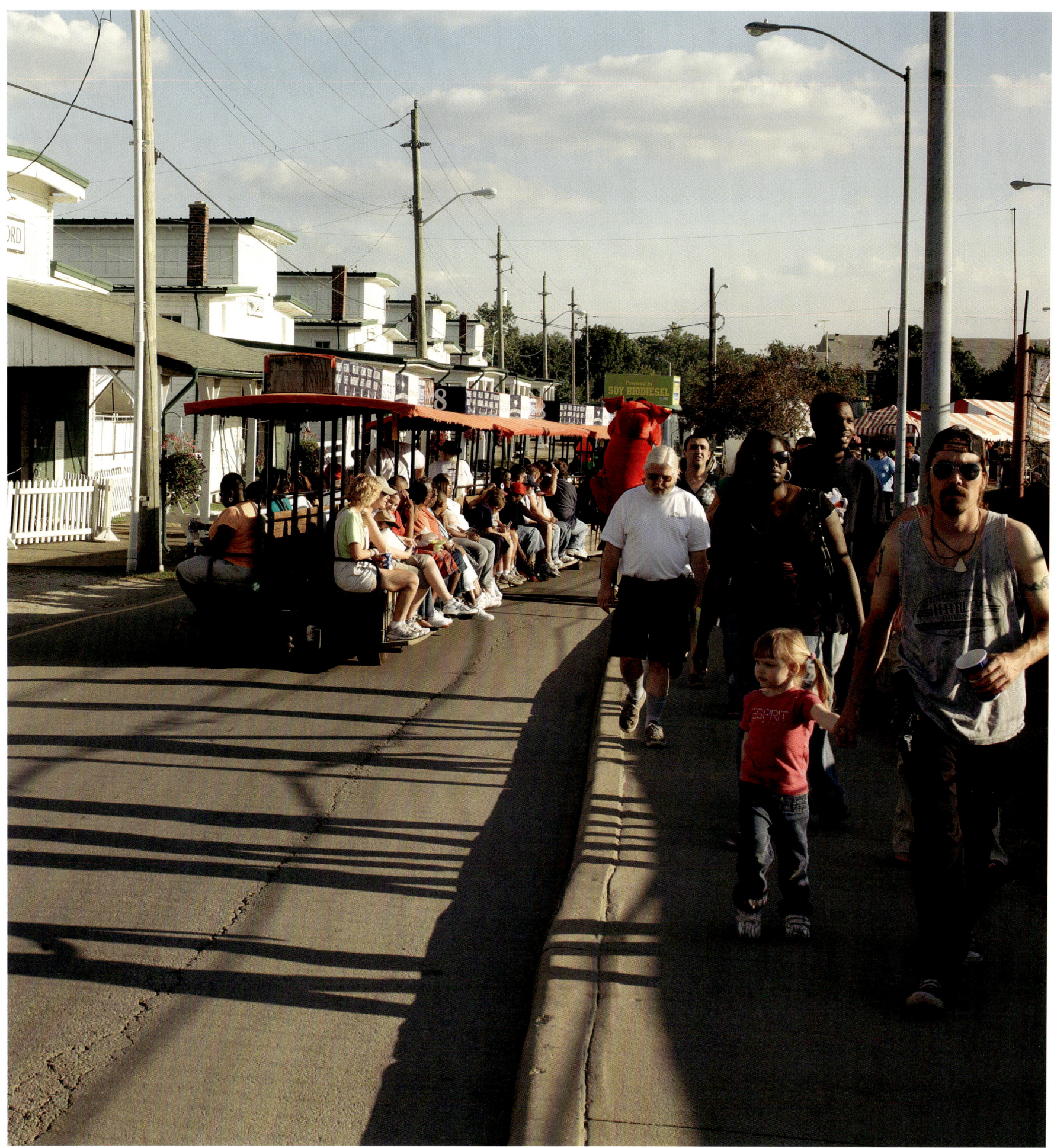

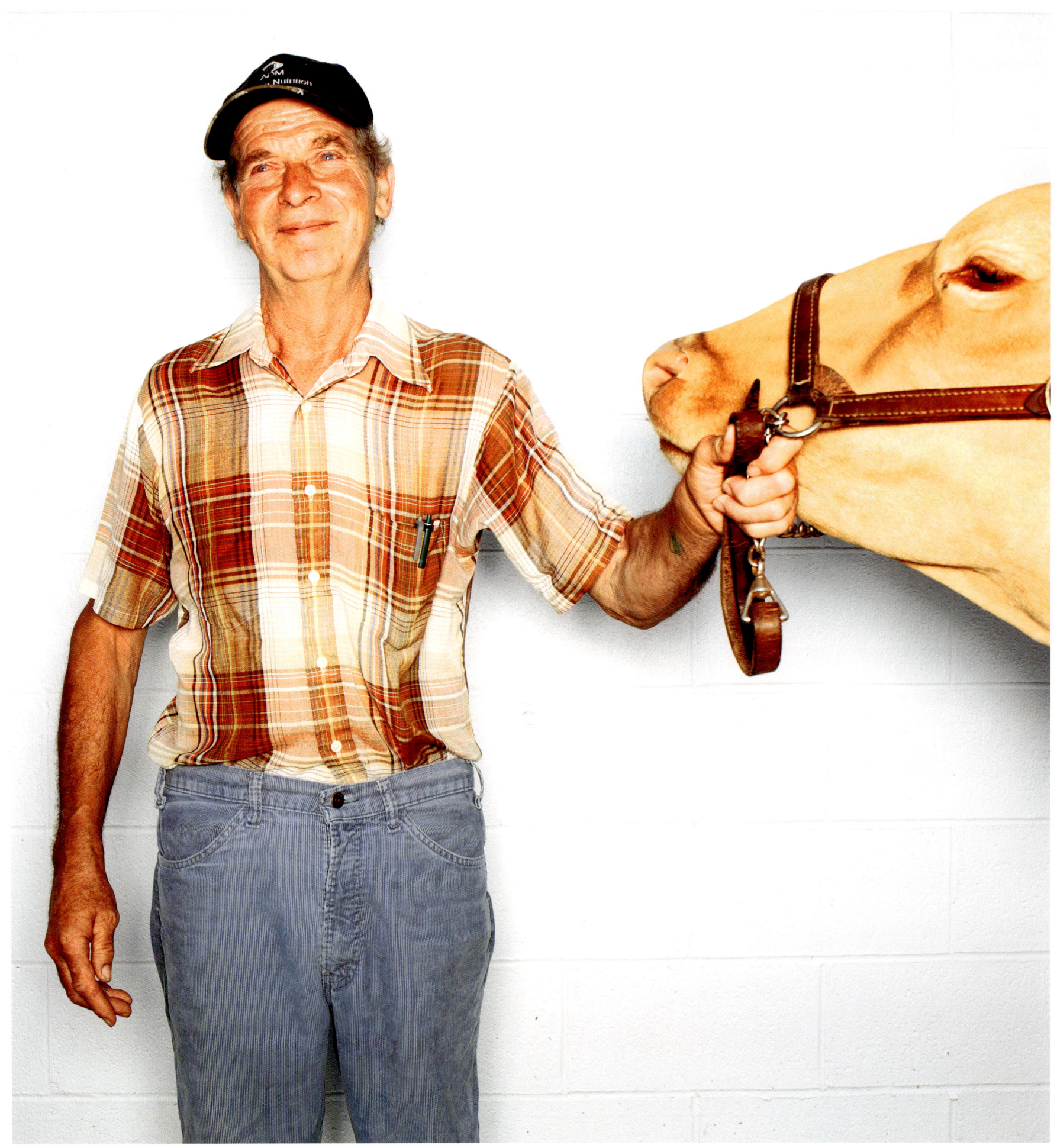

There's an old saying that applies to the fair: "The more things change, the more they stay the same." Balloon races were a part of the fairs in the early twentieth century and still are. The Rocket and the midway have not changed much in fifty years of fair going. People we do not change easily. The fair helps that process by aligning tradition with innovation. Breeds of sheep have changed a lot in the past 150 years, and even though standards by which they are judged have changed, the actual ritual of showing and judging has not. Rituals give us stability and meaning in a world that is always changing. County fairs classify a wide range of daily activities into categories that are ritually evaluated. These utilitarian activities (e.g., baking a cake or raising chickens) are transformed by the ritual quality of the fair to aesthetic categories that lend themselves to artful critique (e.g., baking the "best cake"). The transformation is created by moving an otherwise mundane activity into the public sphere for evaluation by the community. These objects and activities can be viewed as representations of idealized life, or icons, a statement of what life could be like. The evaluation of these icons, and the resulting approval or lack thereof from the participants, becomes a process of articulating social values for the sponsoring community.

The overall organization of fairs follows predictable patterns in most of Indiana. Even though they are labeled as agricultural in nature, they incorporate a variety of elements that reflect a mix of urban and rural traits. Some may be specifically 4-H or often have open classes of competition for community participation. Most fairs also feature local school projects, especially elementary age projects. All fair boards stay with the themes of agriculture, entertainment, education, commerce, and industry with some variations. This structure is important because it may serve as the fair board's idea of a model of the larger community and reflect basic assumptions about the nature of the fair in the population they represent. It is also a commentary about the prioritization of community assets—the fair board presents what they think the community wants.

Harold Miller's photographs in this book represent an examination of these activities in their broadest cultural meaning. Who are the participants in the fair, who organize and run it, who enter the various competitions, and who are spectators? What is the relationship of entries and judging, to the fair, and to the larger community (e.g., who has the best chicken and what will that do for entries for next year)? And most important: what is the meaning of this institution (the fair) to these people that sustain it from year to year? As we look at the photographs that illuminate our summer Hoosier world, take notice of the fact that many of them are profiles. They are profiles both literally and figuratively—they frame and illustrate both the fair and individuals with memorable definition. The other noticeable thing about these representations is that they always focus on people and the things that they produce. These images also give the fair meaning, one centered on the participants who create these celebrations, and the communities of which they are a part. They also create a simultaneous dichotomy and connection between individualism and the larger social unit. The individual competition of the best of the best and the connections of family, friends, and acquaintances brought together in an annual ritual as an outlet for public creativity.

One function, played down by some, and the focus of many, is that of entertainment. In an era of increased costs and time constraints, the county fair offers us an easy escape from our busy world. It is a place for family fun and relaxation for many participants. From grandstand shows to the midway, from animal shows and circus performers to petting zoos, the fair provides inexpensive family outings close to home. It also holds many of the keys to maintaining and renewing family ties in a world that otherwise discourages those values.

Understanding county fairs in Indiana is a way of understanding ourselves and our communities. Changes in the content and venue of fairs reflect the urbanization and modernization of a once rural America. People's firsthand knowledge of agriculture has diminished drastically in the twenty-first century and probably will continue to fade as Indiana's population becomes more urban-centric. Some fairs have made an effort to continue to incorporate agriculture to educate "those who eat but don't grow" and the growing number of hobby farmers who draw subsistence from urban occupations but involve their families with horticultural or pastoralist avocational pursuits. Other fairs have changed to strictly entertainment as a means of creating a venue for political and business promotion. Though fewer people in our large cities have contact with the fairs in the ways most did only a few decades ago, they are still present and still have an effect upon our Hoosier lifestyle in important ways. State fairs with attendance figures in the hundreds of thousands per week and extravagant pageants incorporating agriculture, education, racing, and entertainment exist in every state.

The emphasis on agriculture may be lessened in some places to make way for more business, but most county fairs still emphasize their agrarian roots. Also in an abstract sense, fairs may represent the values and norms that the sponsoring community wishes to see rather than the mundane realities of life as it actually is. In this new millennium it is important to note that fairs in Indiana are nearly two hundred years old and still with us. As annual rituals of American modernization, they reflect not only our past, but also the present and future.

Opposite: Dean Kronk, Elkhart County Fair

PHOTOGRAPHS

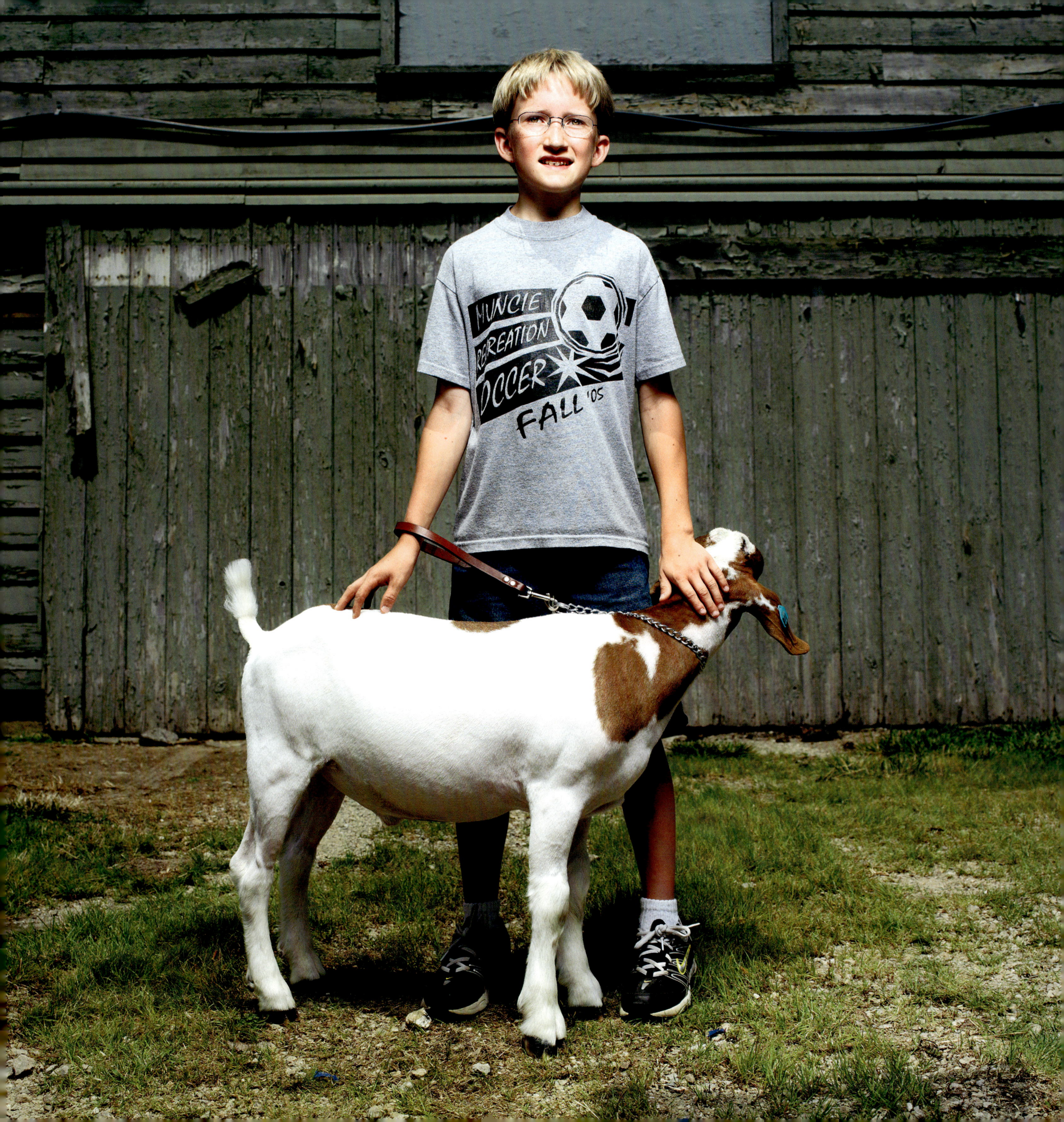

Drew Smith, Delaware County Fair

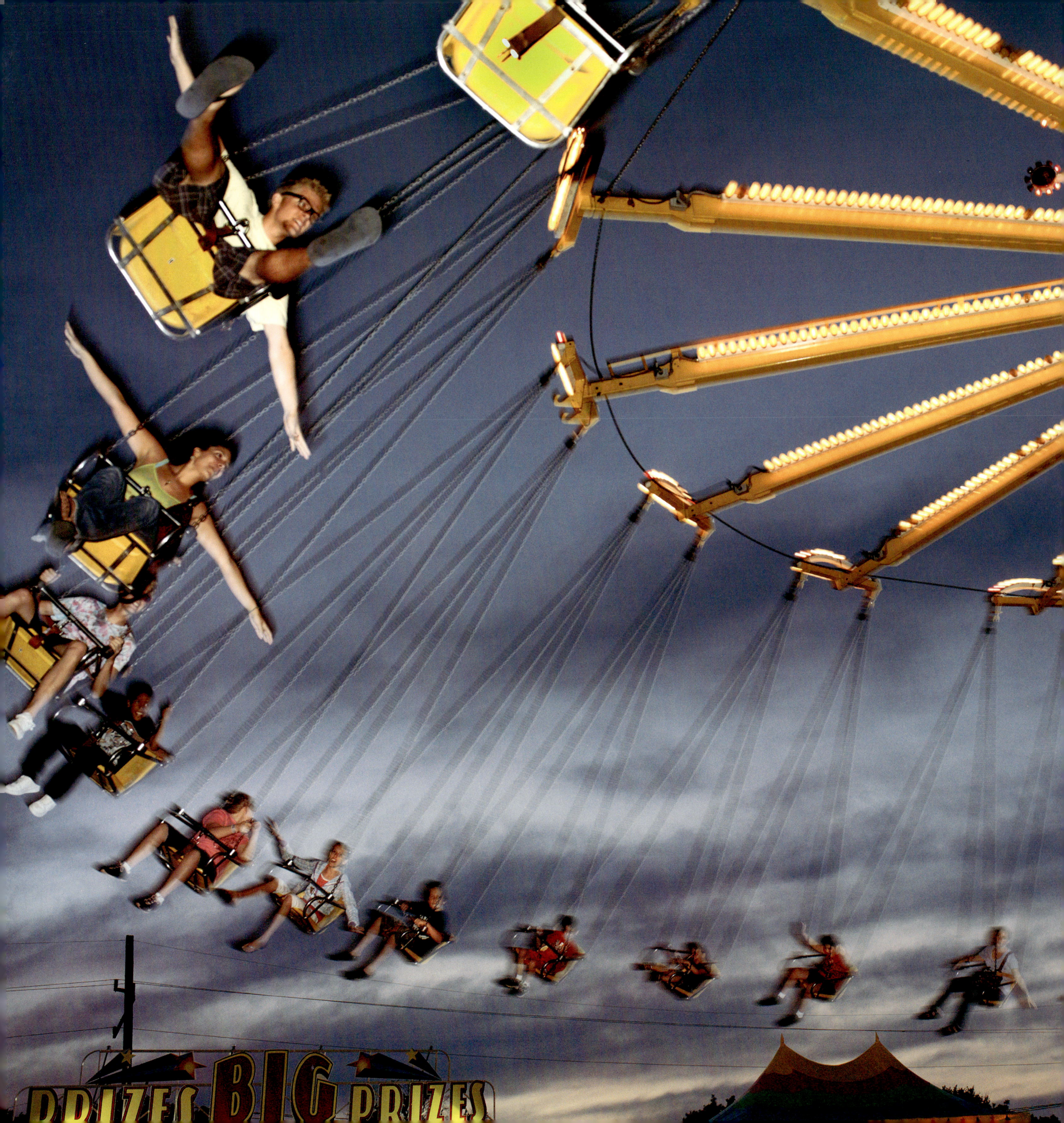

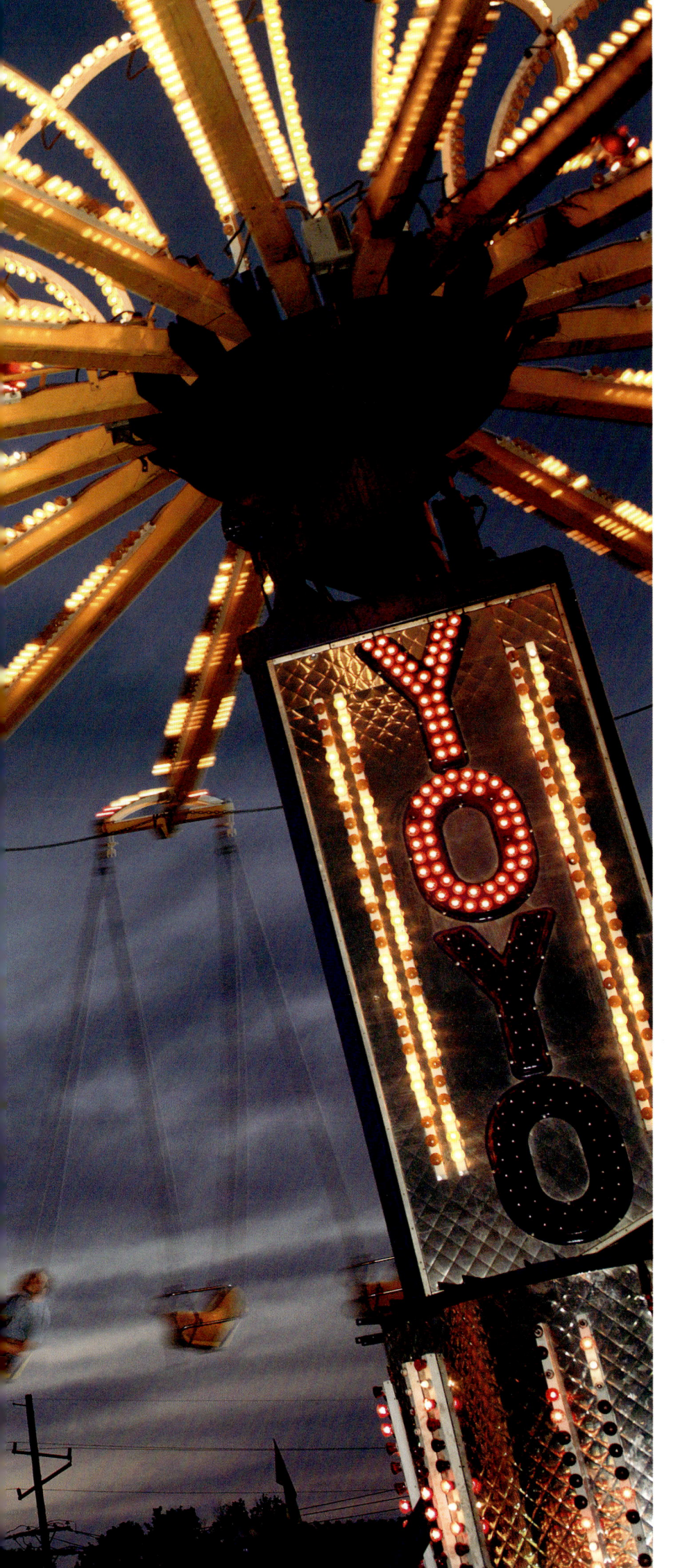

Indiana State Fair

RESEARCHERS HAVE RECENTLY DISCOVERED THAT CHICKENS MAY HAVE BEEN FIRST DOMESTICATED IN VIETNAM MORE THAN TEN THOUSAND YEARS AGO.

Linea Vincent, Indiana State Fair

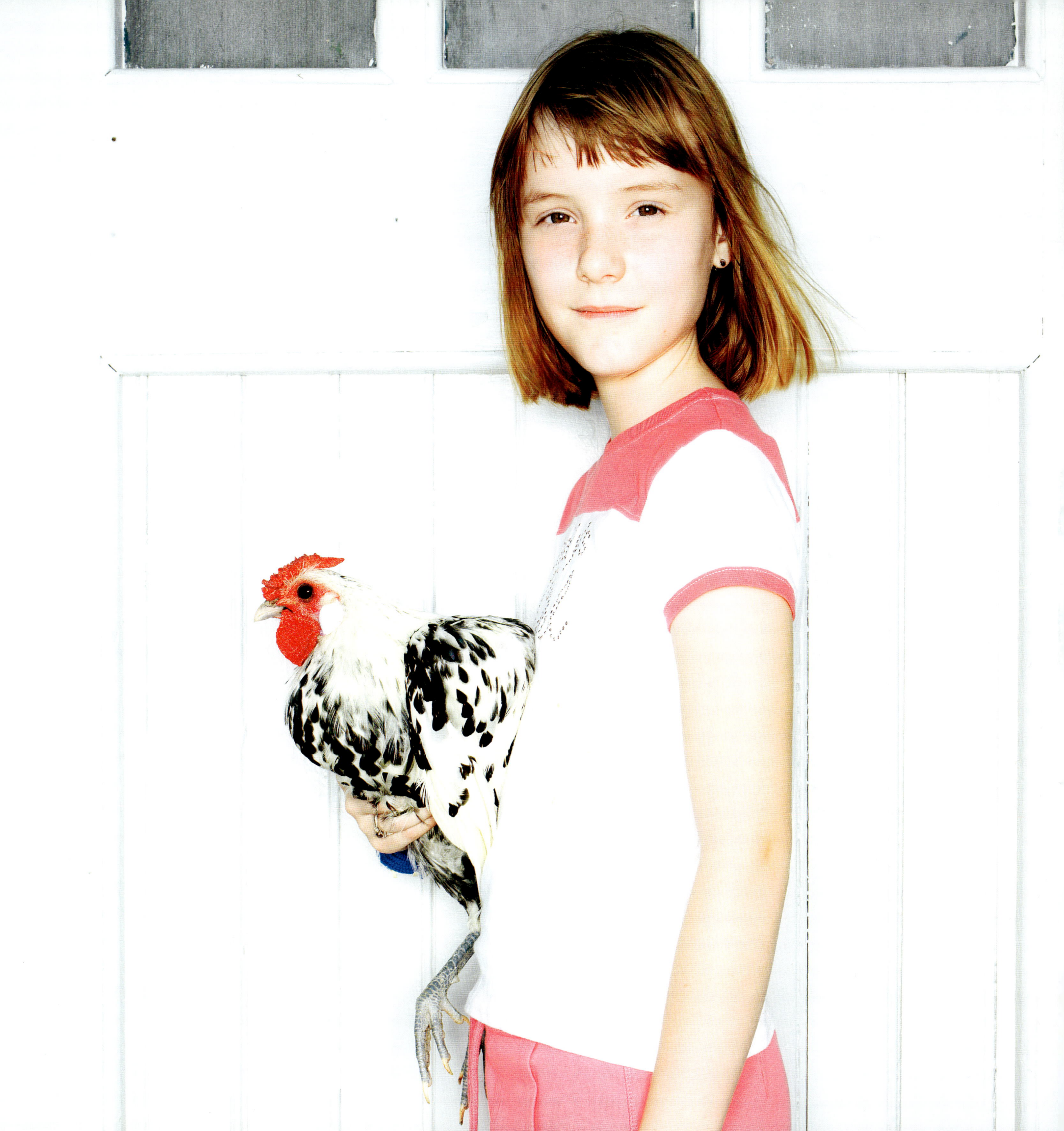

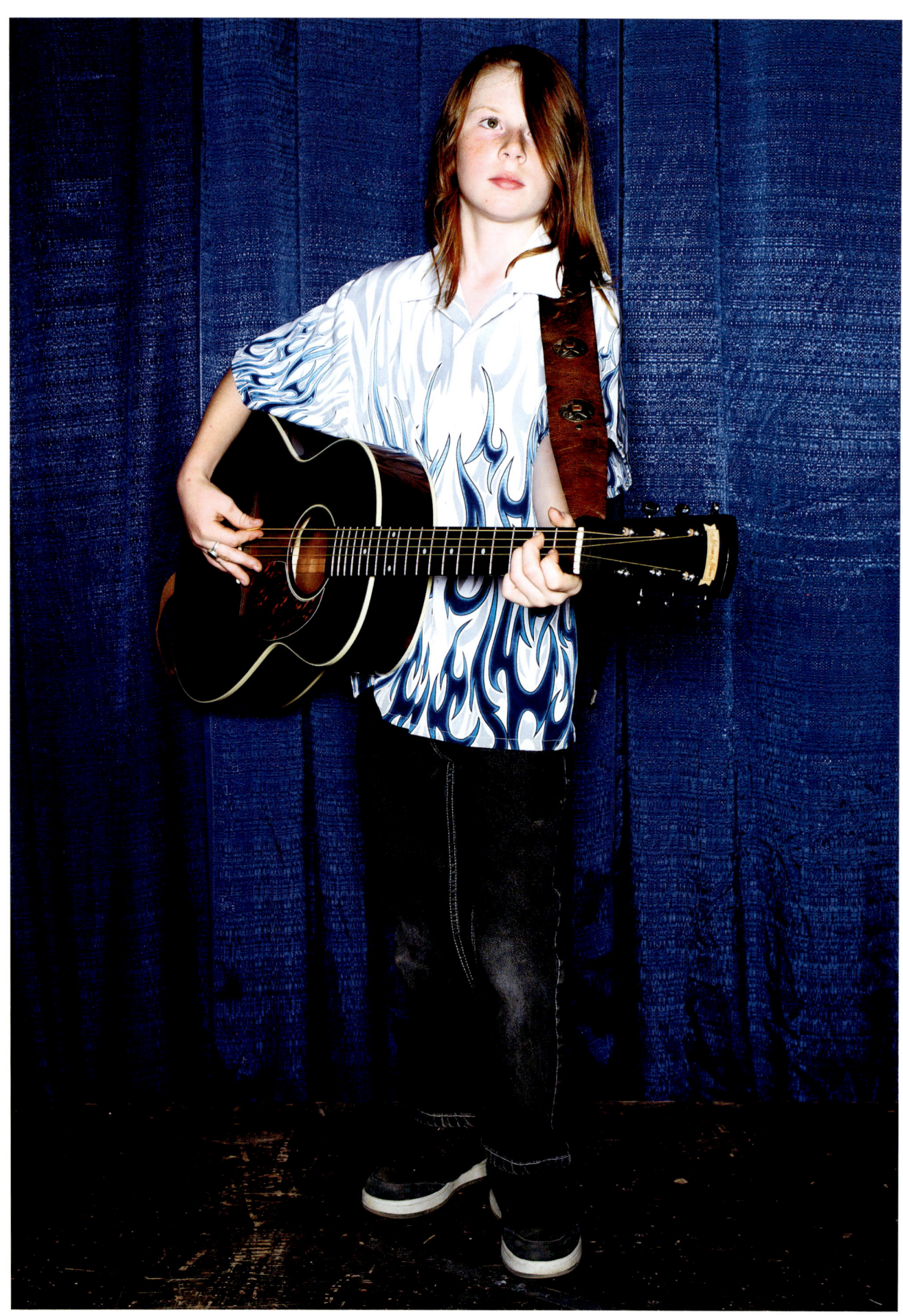

Carson Diersing, Marion County Fair

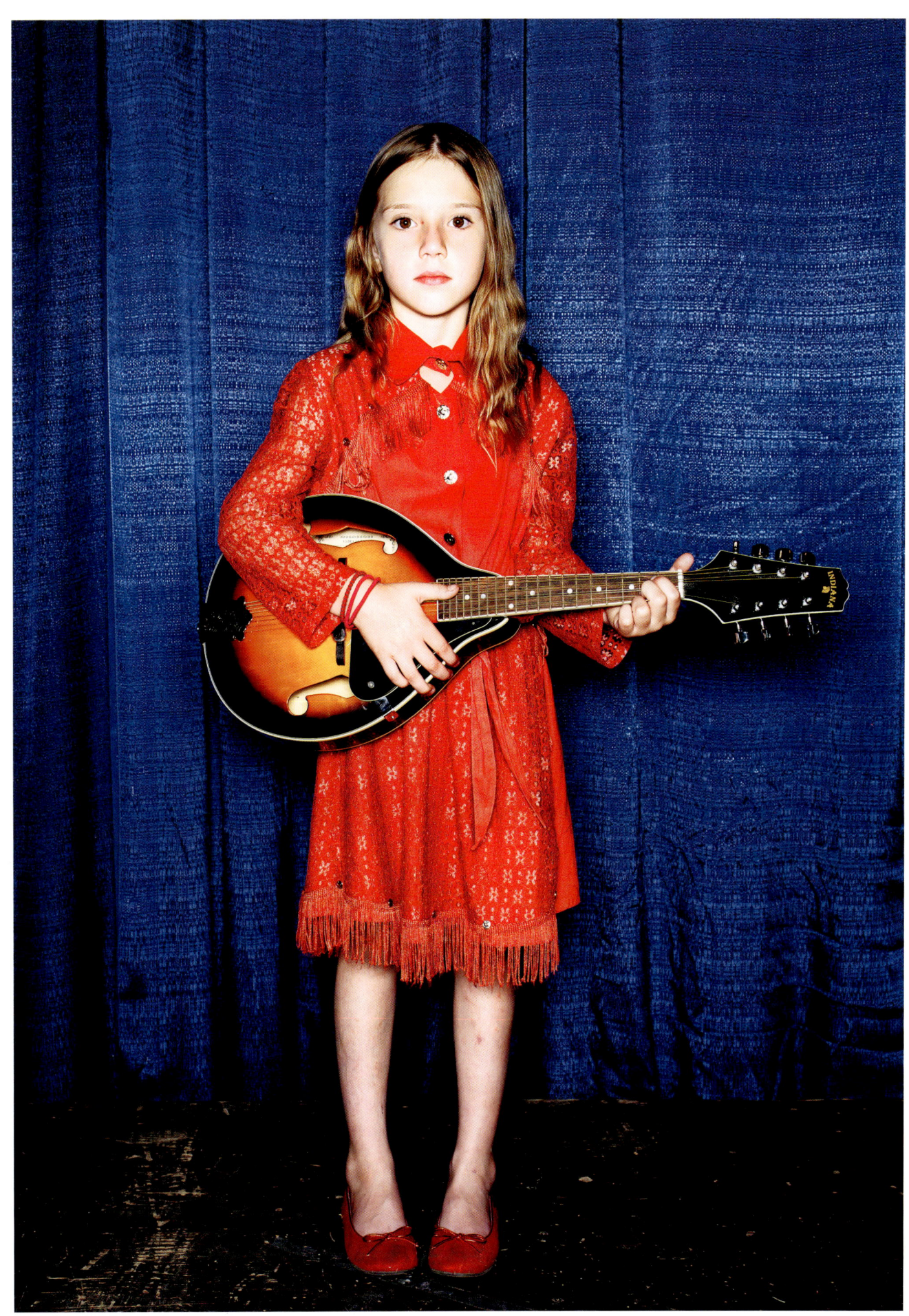

Carylnn Diersing, Marion County Fair

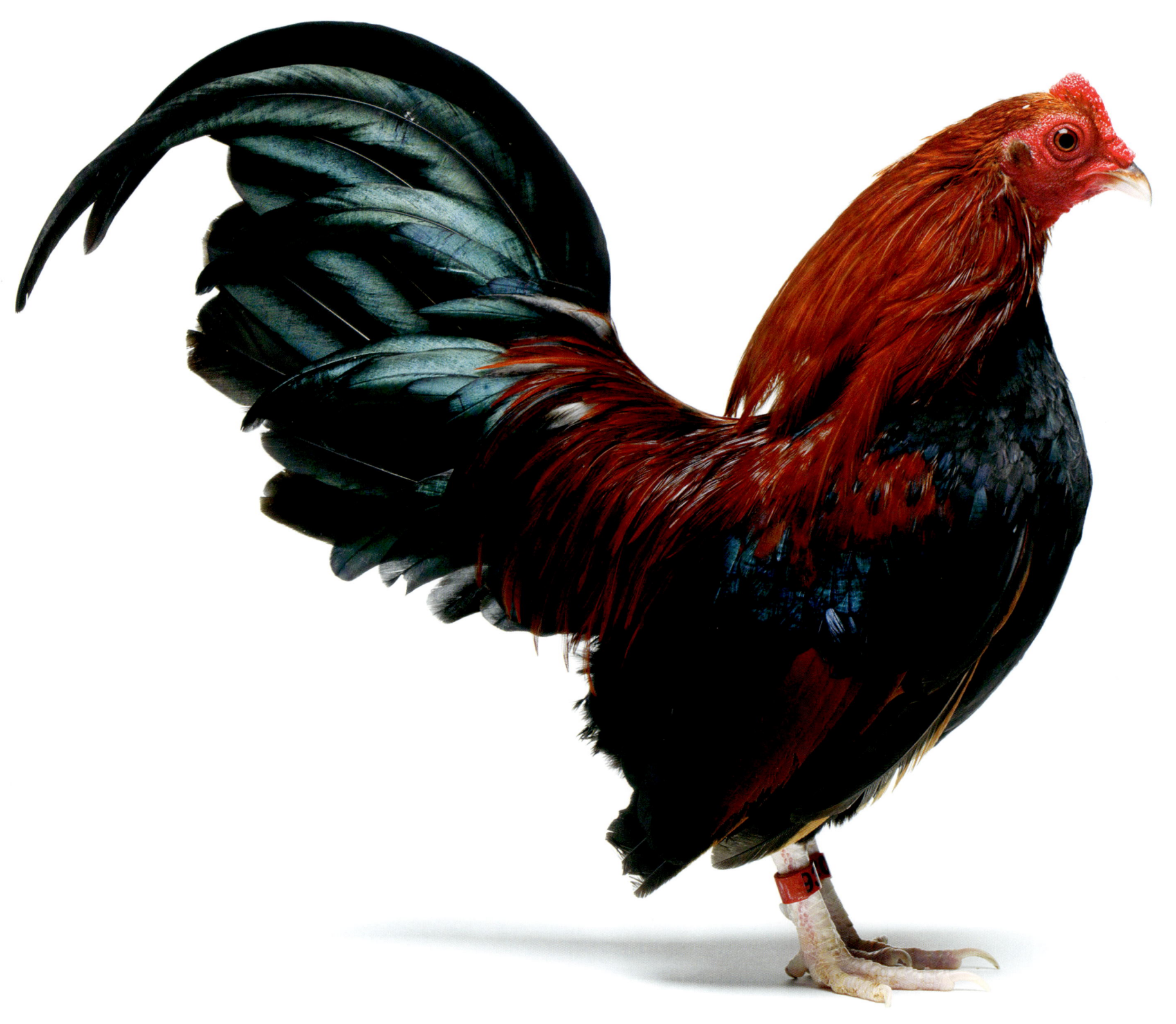

Black Breasted Red Cockerel, Indiana State Fair

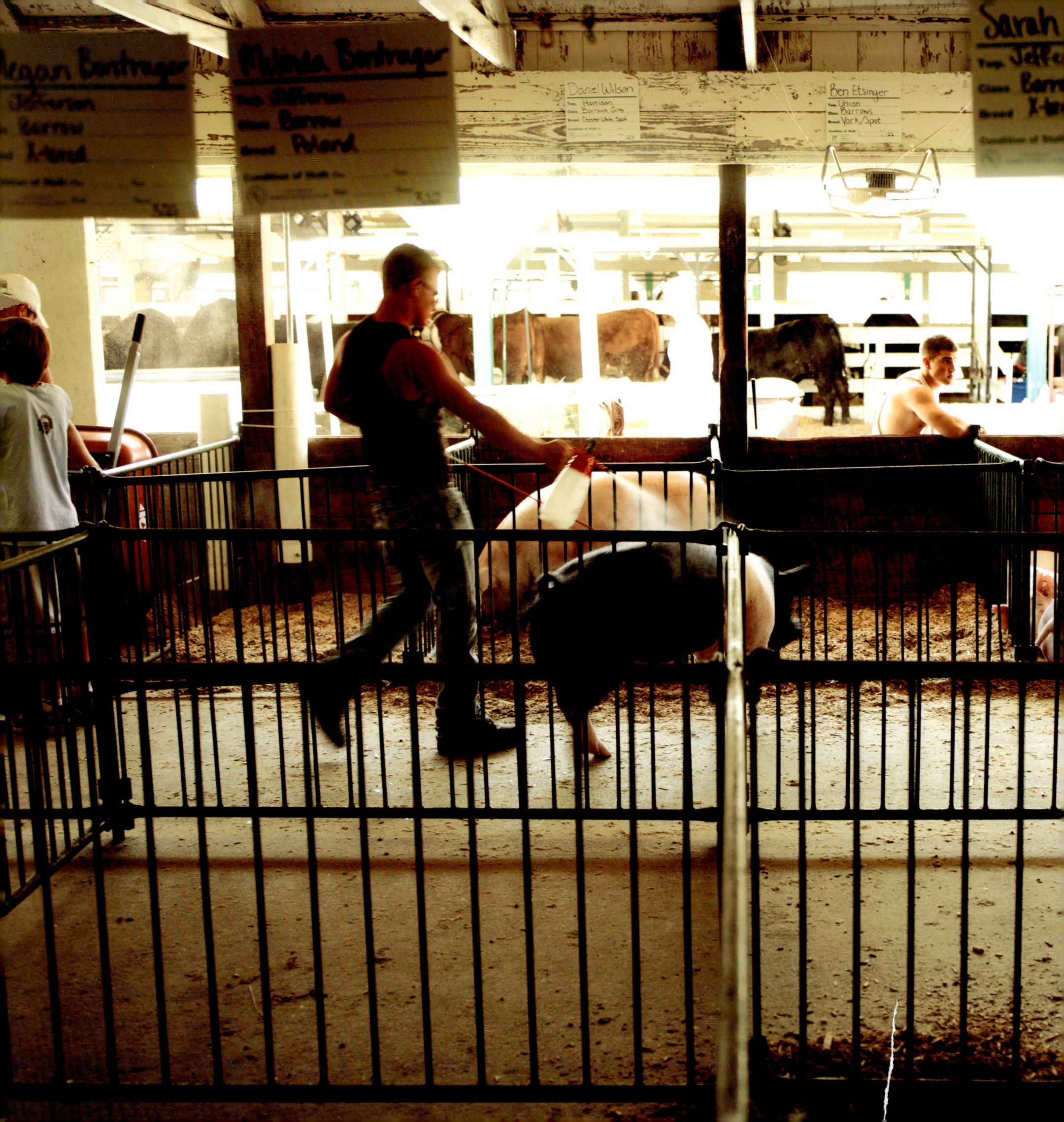

Elkhart County Fair

Marie Perry, Marion County Fair

Don Eash, Jay County Fair

Elkhart County Fair

DEBATE RAGES ON JUST WHO INVENTED OR POPULARIZED THE CORN DOG. ACCORDING TO FOOD SERVICES OF AMERICA, A LEADING FOOD SERVICES DISTRIBUTOR, "MOST OFTEN CITED ARE THE FLETCHER BROTHERS (CORN DOGS IN TEXAS) AND JACK KARNIS (PRONTO PUPS IN OREGON AND MINNESOTA). THE RECORDS OF THE U.S. PATENT AND TRADEMARK OFFICE CONFIRM PRONTO PUPS WERE INTRODUCED IN 1942. ACCORDING TO THE FOOD HISTORIANS, THIS IS ABOUT THE SAME TIME CORN DOGS MADE THEIR WAY TO THE TEXAS STATE FAIR."

Indiana State Fair

Susie Knight, Indiana State Fair

Destiny Walden, Monroe County Fair

ACCORDING TO THE WEB SITE THEPIGSITE.COM, A PIG WILL EAT APPROXIMATELY 4 PERCENT OF ITS BODY WEIGHT PER DAY.

Kyle Gideon, Indiana State Fair

Owen County Fair

Jennifer (left) and Cally Scott, Indiana State Fair

DEERE AND COMPANY, FOUNDED IN 1837 (COLLECTIVELY CALLED JOHN DEERE), HAS GROWN FROM A ONE-MAN BLACKSMITH SHOP INTO A CORPORATION THAT TODAY DOES BUSINESS AROUND THE WORLD AND EMPLOYS APPROXIMATELY 52,000 PEOPLE.

Kenneth Grubb, Monroe County Fair

Opposite: Ibrahim and Taimah Khan, Indiana State Fair
Top: Stephen and Codi Sanders, Indiana State Fair
Below: Linda Dieg, Indiana State Fair

Heather Duthie, Marion County Fair

Opposite: Jimmy and Donna Hargett, Indiana State Fair
Top: Philip and Heather Wilkins, Indiana State Fair
Below: Mike Duke and Janice Trotter, Indiana State Fair

Cindy Kelley, Elkhart County Fair

JUGGLING CAN TRACE ITS HISTORY AS FAR BACK AS ANCIENT EGYPT. THE TOMB OF AN UNKNOWN PRINCE FEATURED A WALL PAINTING OF FEMALE DANCERS AND ACROBATS JUGGLING BALLS IN THE AIR. IN ROMAN TIMES, SIDONIUS APOLLINARIS, AN OFFICER IN A ROMAN LEGION, ENTERTAINED HIS TROOPS BY PERFORMING JUGGLING TRICKS WITH BALLS.

Tony Mills, Marion County Fair

Ron Greenwell, Indiana State Fair

Above: Hannah Rawlinson, Indiana State Fair
Opposite: Hannah Shaffer, Delaware County Fair

Washington County Fair

Elkhart County Fair

Polish White Crested Black Hen, Indiana State Fair

Elkhart County Fair

Dalton and Audra Sloan, Knox County Fair

QUEEN ELIZABETH II OF ENGLAND REPORTEDLY OWNS ONE OF THE LARGEST COLLECTION OF TIARAS IN THE WORLD. THE COLLECTION INCLUDES CROWNS FROM THE ROYAL FAMILY AND GIFTS MADE BY ROYALTY FROM OTHER COUNTRIES.

Natalie Bowman, Indiana State Fair

WABASH CARNEGIE PUBLIC LIBRARY

ON THE AVERAGE, EACH AMERICAN CONSUMES 23.2 QUARTS OF ICE CREAM, ICE MILK, SHERBET, ICES, AND OTHER COMMERCIALLY-PRODUCED, FROZEN DAIRY PRODUCTS PER YEAR.

Knox County Fair

Washington County Fair

Christina Smith, Indiana State Fair

Opposite: (Left to right) Julie Burch, Mollie Hiatt, and Chandler Appleby, Marion County Fair
Above: Clevenger, Indiana State Fair

David Chandler, Monroe County Fair

Jordan Dukes (left) and Taylor Woodmans, Marion County Fair

Kanani Price, Indiana State Fair

THOSE WHO WORK FOR CARNIVALS ARE OFTEN KNOWN BY THE SLANG TERM "CARNY" OR "CARNIES," A TERM POPULARIZED IN THIS COUNTRY IN THE 1930S. LONGTIME CARNIES DEVELOPED A LANGUAGE ALL THEIR OWN, WITH SUCH SLANG WORDS AS "MOOCH" FOR AN INDIVIDUAL WHO ASKS FOR A FREE GAME OR PRIZE, AND "OATS" FOR STOLEN MONEY FROM A CONCESSION.

Knox County Fair

Josh Maroska, Marion County Fair

Marion County Fair

Dan Jean, Indiana State Fair

Opposite: Hunter (left) and Beau Brown, Delaware County Fair

Knox County Fair

Monty Bontrager, Elkhart County Fair

Above: Elkhart County Fair
Right: Dubois County Fair

Indiana State Fair

Owen County Fair

Opposite: Randy and Vickee Morton, Indiana State Fair
Left: Brian Smock and Christina Trewn, Indiana State Fair
Right: Phyllis Hebble, Indiana State Fair

THE TERM MIDWAY—THE PLACE WHERE AMUSEMENT RIDES, FOOD BOOTHS, AND OTHER ENTERTAINMENT IS LOCATED AT A FAIR—ORIGINATED AT THE WORLD'S COLUMBIAN EXPOSITION HELD IN CHICAGO, ILLINOIS, IN 1893.

Elkhart County Fair

David Sosbe, Monroe County Fair

Elkhart County Fair

Knox County Fair

Left: Ashley Harrold, Delaware County Fair
Opposite: Sue Beecher, Indiana State Fair

Todd Peacock, Indiana State Fair

Opposite: Michelle Mills, Marion County Fair
Above: Elizabeth (left) and Sarah Smoot, Indiana State Fair

Opposite: Jerry Landess, Jay County Fair
Above: Chad Peter, Jay County Fair

Kim Boutwell, Marion County Fair

Knox County Fair

DEMOLITION DERBIES HAD THEIR START IN THE 1950S, ALTHOUGH THERE ARE REPORTS OF SUCH EVENTS BEING HELD AS EARLY AS THE 1930S WITH SURPLUS MODEL T FORD AUTOMOBILES. MOST PARTICIPANTS USE CARS THAT ARE RID OF THEIR INTERIOR FIXTURES, PLASTIC, GLASS, AND LIGHTS. THE CARS ARE ALSO EMBLAZONED WITH GARISH COLORS AND MESSAGES.

Dubois County Fair

Above and Opposite: Alisha Hiber, Marion County Fair

Single Comb Black Minorca Cock, Indiana State Fair

Caleb Fosnight, Delaware County Fair

Cathy Smith (left) and Mekayla Diehl, Elkhart County Fair

Opposite: Brian Harvey, Indiana State Fair
Above: Tim Stohlman, Indiana State Fair

Sarah Ruble, Owen County Fair

ALTHOUGH WHO INVENTED COTTON CANDY IS OFTEN DISPUTED, IN 1897 TWO CANDY MAKERS FROM NASHVILLE, TENNESSEE—WILLIAM MORRISON AND JOHN C. WHARTON—CREATED A MACHINE THAT MADE COTTON CANDY BY MELTING A SUGAR MIXTURE AND THEN USING CENTRIFUGAL FORCE TO PUSH THE MELTED SUBSTANCE THROUGH A SCREEN. THE SCREEN CREATED THE WISPY THREADS THAT WERE COLLECTED ONTO A PAPER OR CARDBOARD CONE.

Dubois County Fair

Amy (left) and Ashley Lapham, Indiana State Fair

Lynn Piland, Monroe County Fair

Maria Haag, Indiana State Fair

Elkhart County Fair

Craig Ambrosett, Delaware County Fair

Opposite: Kyle Stovall (left) and Gregory Eckrich, Indiana State Fair
Top: Wanda Harlin (left) and Laura Lewis, Indiana State Fair
Below: Joseph Lese (left) and Eric Houghtalen, Indiana State Fair

Opposite: Katie Jones, Indiana State Fair
Above: Chelysie Vandever, Marion County Fair

Tara Jones, Indiana State Fair

MANUFACTURED BY INTERNATIONAL HARVESTER, FARMALL TRACTORS WERE THE FIRST GENERAL-PURPOSE TRACTORS WITH NARROWLY SPACED FRONT WHEELS. THESE NIMBLE TRACTORS WERE PAINTED BATTLESHIP GRAY UNTIL THE 1930S, WHEN THEY BEGAN SPORTING THEIR FAMILIAR "FARMALL RED" COLOR.

Thomas Jordan Figg, Monroe County Fair

Left: Wesley Richardson, Indiana State Fair
Opposite: Hailey and Timm Minkar, Indiana State Fair

Above: Gail Spegal, Marion County Fair
Opposite: Christy Thuer, Marion County Fair

ACCORDING TO THE U.S. DEPARTMENT OF AGRICULTURE, IN 2006 CALIFORNIA PRODUCED THE LARGEST VOLUME OF ICE CREAM AND RELATED FROZEN DESSERTS IN THE UNITED STATES, FOLLOWED BY TEXAS, INDIANA, PENNSYLVANIA, MASSACHUSETTS, AND MINNESOTA.

George Scybert, Indiana State Fair

Jackson County Fair

Susan Fitzwater, Marion County Fair

Elkhart County Fair

Indiana State Fair

DEEP FRIED COOKIE DOUGH

DEEP FRIED Oreo Cookies

DEEP FRIED PEPSI

DEEP FRIED PEANUT BUTTER CUPS

Home of the Famous...
DEEP FRIED
SNICKERS... $4.00
MILKY WAY... $4.00
REESE'S... $4.00
OREOS... $3.50

NEW!
FRIED CHOCOLATE CHIP COOKIE DOUGH $4.00
(4 PER ORDER)

SPECIAL
CANDY COMBO
1 Snicker or Milky Way
And...
1 Reese's
And...
2 Oreos

SKATE SHOP

COLD DRINKS • BURGERS • HOT DOGS • HOT COFFEE
BAR-B-Q • SAUSAGE
FRENCH FRIES • CHICKEN

CAROUSEL

HOT SANDWICHES
Baskets

Christine Rienecker, Indiana State Fair

Jonathan Faulkner, Monroe County Fair

Stephanie Hurlock, Marion County Fair

Elkhart County Fair

THERE ARE MORE CHICKENS IN THE WORLD THAN ANY OTHER BIRD. LEFT ALONE IN NATURE, THEY CAN LIVE ANYWHERE FROM FIVE TO ELEVEN YEARS.

Black Breasted Red Cock, Indiana State Fair

Jessica Vandenbark, Indiana State Fair

Elkhart County Fair

Kaycee Tella, Owen County Fair

ACCORDING TO INDIANAFARMDIRECT.COM, A WEB SITE FOR HOOSIER FARM FAMILIES, INDIANA RANKS FOURTH IN THE UNITED STATES FOR PRODUCTION OF CORN FOR GRAIN. ON AVERAGE, INDIANA FARMERS HARVEST 884 MILLION ACRES OF CORN A YEAR. MOST INDIANA CORN IS USED FOR ANIMAL FEED, ALTHOUGH AN INCREASING AMOUNT IS GOING INTO THE ETHANOL INDUSTRY FOR FUELS FOR AUTOMOBILES. A SIGNIFICANT PORTION OF THE CORN CROP ALSO GOES INTO THE SWEETENER INDUSTRY. EVERY TIME YOU OPEN A SOFT DRINK YOU ARE CONSUMING PART OF THE CORN CROP.

Will Robinson, Knox County Fair

Foster Family, Marion County Fair

Susan Zoppe, Indiana State Fair

Scarlet Rose, Indiana State Fair

Philip Long, Monroe County Fair

"ALWAYS REMEMBER, A CAT LOOKS DOWN ON MAN, A DOG LOOKS UP TO MAN, BUT A PIG WILL LOOK MAN RIGHT IN THE EYE AND SEE HIS EQUAL."

—WINSTON CHURCHILL

Clorinda Tharp, Indiana State Fair

Dan Westfall, Jay County Fair

Indiana State Fair

Jesse Bollenbucher, Indiana State Fair

Martha Lane, Indiana State Fair

Knox County Fair

FIRST MANUFACTURED BY WISDOM INDUSTRIES IN 1983 (PATENTED IN 1986), THE GRAVITRON RIDE USES CENTRIFUGAL FORCE TO PIN RIDERS AGAINST ITS WALLS AT UP TO FOUR TIMES THE FORCE OF GRAVITY.

Jenna McHenry, Marion County Fair

Indiana State Fair

Jackson County Fair

42410

42412

Opposite: Emily English (left) and Amanda Deutsch, Indiana State Fair
Above: Grant Sajdak and Emma Boehmke, Indiana State Fair

Judges Joyce, Treena, Madonna, Donna, and Martha, Delaware County Fair

Bob Morrow, Jay County Fair

Taylor Trobaugh, Indiana State Fair

Pete Akers, Indiana State Fair